MW01514280

Stained Glass Mandalas

By Vickie McDonough

Enjoy coloring over 50 unique mandalas while learning tidbits of history and interesting facts about stained glass.

Maverick

Press

Published in 2017 by Maverick Press™
First edition; First printing
Copyright © Vickie McDonough
www.vickiemcdonough.com

Some images courtesy of Created by Visnezh - Freepik.com

All rights reserved. No part of this book may be reproduced, stored in a retrieval system or transmitted in any form or by any means, including but not limited to information storage and retrieval systems, electronic, mechanical, photocopying, recording, etc. without prior written permission in accordance with the provisions of the Copy Right Act of 1956 (as amended). Any person or persons who do any unauthorized act in relation to this publication may be liable to criminal prosecution and civil claims for damages.

978-0-9971767-1-1

Test Your Colors Here

"Stained glass" is the term used for pieces of colored glass joined together with strips of lead to form a picture or design.

The lead that is placed between cuts of
glass in a stained glass design is called "came."

The largest handmade stained glass window is believed to be in the Roman Catholic St. Mary's Cathedral Basilica of the Assumption in Covington, Kentucky. It measures 67' x 24'.

Stained glass windows were used in early Catholic churches to depict scenes from the Bible because the majority of people in their congregations were illiterate.

*After a 200 year decline in stained glass interest,
glassmakers Louis Comfort Tiffany (1848-1933)
& John Farge (1835-1910), revived interest
with their colorful and unique products.*

In the 1930's, when war loomed over Europe, many
stained glass windows were taken apart piece by
piece and stored in secure places.
After the war the windows were carefully reinstalled.

The full-sized sketch (pattern) of a stained glass design is a called cartoon.

Stained glass has been around since the third or fourth century, but it blossomed in the 12th century with the rise of Gothic cathedrals. Now only 10% of all stained glass is used in churches. Most is found in residential and industrial architecture.

*The 12th and 13th centuries in Europe are considered
the Golden Age of Stained Glass, but, during the
Renaissance period, stained glass took second place
to painted glass.*

The stained glass movement in America was started by an Englishman living in the U.S., William Jay Bolton, who made his first window for a church in New York in 1843. He was only in business six or seven years before he returned to England.

Stained glass is made by fusing together some form of silica, such as sand, an alkali like potash or soda, and lime or lead oxide.

The color in glass is created by adding a metallic oxide to the raw materials. Copper oxide, under certain conditions, produces ruby, blue, or green glass.

The addition of chromium and iron oxide creates green shades in glass. Golden, yellow, and vermilion glass is sometimes colored with uranium, cadmium sulfide, or titanium. Ruby colored glass is made by adding in gold.

Today's stained glass is made almost the same way it was back in the Middle Ages. Glass for leaded glass windows starts out as a molten lump that is attached to one end of a blow pipe. Air is blown in to form a cylinder, which is then cut, flattened, and cooled.

There are two basic types of stained glass: cathedral and opalescent. Cathedral comes in many colors, but it is always translucent. Opalescent glass allows light in, but you cannot see through it.

Full mouth blown antique refers to art glass that is produced in the historical mouth-blown cylinder method by a master glassblower.

Bevels are clear plate glass with edges that have been ground and polished to an angle other than 90 degrees. Transmitted light is refracted resulting in a prism-like effect.

Gluechip glass has a frost-like texture on the surface.
It's made by applying hot animal glue to cold glass and
drying it under controlled conditions. As the glue dries,
it contracts, and the glass surface is chipped, creating
a lovely decorative pattern.

Stained glass is generally scored by hand, using a cutting tool.
The glass is broken apart by hand or with breaking pliers.

Iridescent glass goes through a surface treatment where a layer of metallic oxide is bonded to the hot glass surface just after the sheet forming, resulting in a colorful, shimmering effect.

*Textured glass is created by rolling an embossed
roller over hot glass after it has been poured onto a table.
The rolls are embossed with various textures, which
are imprinted on the glass as the sheet is formed.*

Seedy Glass is glass in which air bubbles are entrapped.
Air or gas is injected into the molten glass prior to forming
the sheet.

Translucent glass transmits light but with diffusion. If you place your hand behind translucent glass, you can see a shadow, but you can't see any of the distinct features.

Once glass has been cut, the pieces are assembled by slotting them into H-sectioned lead came. The joints are soldered, which holds the project together and prevents rattling. The window is weatherproofed by forcing a soft, oily cement or mastic between the glass and the came.

Crown glass is hand-blown glass, which is created by
blowing a bubble of air into a gather of molten glass.
Then it is spun, either by hand or on a table that revolves
rapidly like a potter's wheel. Centrifugal force causes
the molten glass bubble to open up and flatten, which can
then be cut into small sheets.

Rolled glass, also known as "table glass," is made by
pouring molten glass onto a metal or graphite table
and immediately rolling it, either by hand or machine,
into a sheet using a large metal cylinder, similar to rolling
out a pie crust.

Bestselling author Vickie McDonough grew up wanting to marry a rancher, but instead, she married a computer nerd who's scared of horses. She lives out her dreams penning romance stories about ranchers, cowboys, lawmen, and others living in the Old West. Vickie is an award-winning author of more than 45 published books and novellas, with over 1.5 million copies sold. Her novels include *End of the Trail*, winner of the OWFI 2013 Best Fiction Novel Award. *Whispers on the Prairie* was a Romantic Times Recommended Inspirational Book for July 2013. *Song of the Prairie* won the 2015 Inspirational Readers Choice Award. *Gabriel's Atonement,* book 1 in the Land Rush Dreams series, placed second in the 2016 Will Rogers Medallion Award. Vickie has recently stepped into independent publishing.

Vickie has been married over forty years to Robert. They have four grown sons, a daughter-in-law, and a precocious granddaughter. When she's not writing, Vickie enjoys reading, antiquing, creating stained glass projects, watching movies, and traveling. To learn more about Vickie's books or to sign up for her newsletter, visit her website: www.vickiemcdonough.com

OTHER BOOKS BY VICKIE MCDONOUGH

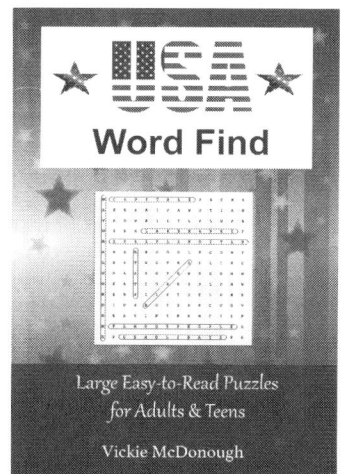